To Mummy with love
From Ronnie & Pat
& the children

19th December 1973

Further Steps in
Drawing and Sketching

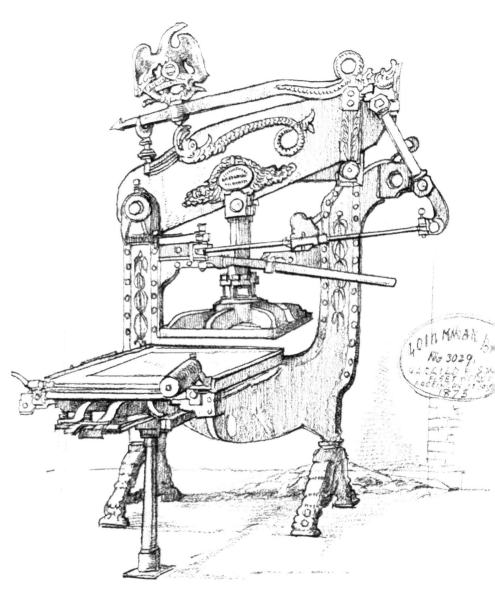

Blair Hugh Stanton's Etching Press

Further Steps in
Drawing and Sketching

written and illustrated by

ADRIAN HILL

LONDON

BLANDFORD PRESS

First published 1972

ISBN 0 7137 0560 4

Acknowledgement is due to the British Museum for permission to reproduce the prints of Old Masters and to publishers from whom short extracts have been quoted. I would also like to thank Gillian Moore for seeing this book through.

A.H.

Printed and bound by Staples Printers Limited at the Gresham Press Woking Surrey

Contents

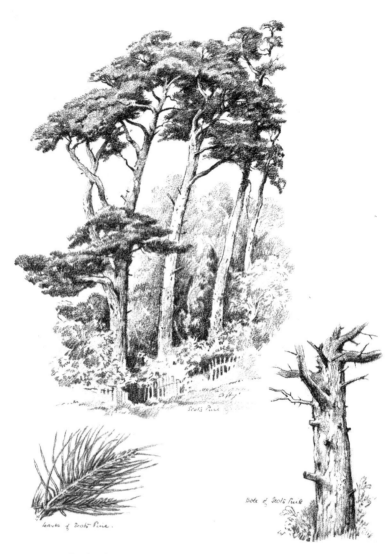

Study of a Scots Pine with details of foliage and bark,
drawn on one sheet of fashion board with carbon pencil

CHAPTER ONE

Introduction

IN his introduction to the second edition of the *Illustrated London Drawing* book, the author, Robert Scott Burn, laments that 'drawing has been generally looked upon as an accomplishment not considered as an essential, as ornamental rather than indispensable in the education of the rising generation'. He goes on: 'First among the helps to bring about another order of things is that of drawing. It is then of importance to place within the reach of all a means by which the art of the varied branches may be easily communicated. The design of the present book is to contribute to this desideratum.'

Certainly a glance at this solid handbook leaves nothing to be desired in the sincere, if verbose language of the text which covers over 140 pages of close print or the 300 pages of engraved illustrations which furnish the required examples to be *diligently copied*, and my real reason for quoting from its introduction is that the reader may share my surprise when I learnt it was published as long ago as 1853! How many similar text books, I wondered, on this very subject of drawing that I have embarked on, have been published in the intervening

Studies on a scrap heap

118 years? And I wonder how many of their authors have unintentionally plagiarised the dictates of their forerunners?

It is a daunting thought, and with it in mind I make no apology for the number of my own drawings that illustrate this present work, for in the end, however much they may lay themselves open to criticism, they are different from what has gone before and easier to 'read' than any amount of evocative words on the subject which may well have been said before, and said perhaps far better. After all, I can take some comfort from

8

Leonardo da Vinci's warning that 'The more you describe the more you will confuse. It is necessary to draw as well as describe.'

For the rest, this book on drawing is something of a sequel or follow-up of my previous *What Shall We Draw?* which was, as suggested by the title, addressed to the young beginner.

In that little work my definition of drawing was question-wise—'How does it go?' In this, where I have a more advanced student in mind, I would put the emphasis on 'How do *you* want it to go?'—implying from the start that drawing is a personal affair and as such any intended instruction must be offered in the form of reminders and suggestions and the friendly 'aside' rather than anything that has a pedagogic or dogmatic slant about it. Who was it who said 'He helps most who does not know all the answers'? Perhaps I comfort myself that I may be amongst that company! For if I am certain of anything, I am sure of this, that the longer I live the less certain I am of making any solemn pronouncement about what is good and what is not, what is right and what is wrong, in the practice of art. Two and two have to make four in most other learned arts and sciences, but in drawing and painting they can make four, fourteen or four hundred, and when applied to the individual each sum can be right. And that is the 'right' of self expression, which should surely be the aim of all who aspire to make a personal contribution to the art of picture making via the way of sound drawing.

Having said that, I was amused to read a recent review of a book on drawing in which the author was quoted as saying 'No-one can teach you how to draw because there are no rules'. I wonder how many times I have been guilty of contradicting that in the following chapters.

CHAPTER TWO

Drawing Now

D RAWING means different things to different people. To
one it denotes hard work as part of one's training to be-
come a painter. To another it remains a mystical or magical
accomplishment, denied to him and therefore it is soon aban-
doned. To some it comes easily, to others not at all! It can be
great fun or a bit of a bore. It is treated with both reverence
and indifference.

A street ir Bath, England. It was too cold to do more!

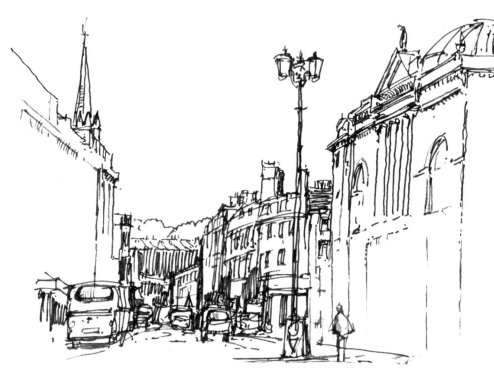

For me drawing has been a life-long love. Indeed, while I am a bit dubious of the poetic or exact significance of the child who is 'born with a silver spoon in his mouth', I can almost persuade myself that I was 'born with a pencil in my hand'. Certain it is that a pencil was my favourite toy and drawing was my favourite game, and if a game can have its serious side, then drawing is still a favourite with me! One of my earliest memories of a childish illness is sitting up in bed with a pad of paper on my lap and a pencil in my hand. My mother's parting injunction to 'be a good boy' was quite unnecessary. I was completely happy, copying something out of a book or drawing 'out of my head'.

The great difference between my early artistic efforts and those produced by children today is that while I was quite content with a pencil for my picture making, the modern generation is only satisfied with a brush fully laden with some vivid colour, which with other exciting or lurid tints covers vast areas of sugar paper with the greatest degree of confidence and generally the smallest degree of drawing ability.

Although painting, in my case, was soon to follow, it was at first largely a matter of colouring what I had drawn. The drawing had to come first, and it had to be right before I began adding the colour. I certainly would not dream of attempting to foister such rigid self-discipline on any reader these days. It just happened to be my way and I do not doubt that when I went to my first little school it helped me to excel with such drawing as was, I believe, rewarded with 'five marks for neatness'.

The urge to improve one's drawing can come at any time, especially in the leisured period of retirement, and I have in mind a certain type of reader, for whom I have much sympathy, who while he is conscious that his lack of drawing is holding him back, would always rather be happily painting than unhappily wrestling with a foreshortened bough of a tree, the gable of a farmhouse or the perspective view of a half open

farm gate; yet at the same time he knows that his picture would look much better if these technical niceties of drawing had been mastered first.

With this artistic tug-of-war in mind, I have attempted in the following chapter to resuscitate object drawing as an attractive, interesting, and often surprisingly enjoyable course of study to adopt, or return to again. If for no other reason it can be counted a diverting recompense for being kept indoors throughout a day of incessant rain!

Ups and downs with an umbrella

CHAPTER THREE

Some of the Objects of Object Drawing

IF you want to know how something grows or how it is made, how it ends up a certain shape and a certain size, in short, how it all comes about, then sit down and draw it. It will have to be a careful drawing; leave the eager, swift impression later for something that is on the move. You will find it is surprising how much you learn while you diligently follow direction, consider length and breadth, compare distance (though it may only be in inches), and then observe surface texture and detail decoration.

Redundant, but still of service to the student: quick sketches in the attic

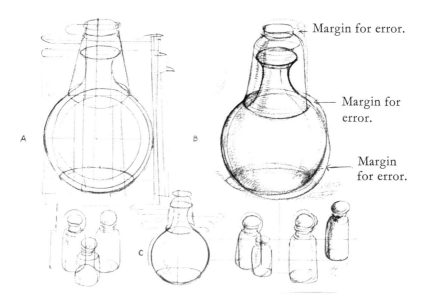

Margin for error.

Margin for error.

Margin for error.

Waterbottle and glass: A, mechanical line drawing; B, freehand approach; C, with modifications

Only by drawing objects will you rightly know why you like one rather than another, and why—which is most important—you chose to draw them in the first place, i.e. their pictorial use to you as an artist. You will find that some objects are easier to draw than others, and I don't mean because they are less complicated in design, for it is often quite the reverse; the very simplicity of the shape, the purity of its outline is often more difficult to capture than an object that is bristling with eye-catching embellishment of wayward design but fascinating to follow for this very reason alone. (The picture above is a good example of this.)

Other objects which are composed of straight lines which all depend on width, angle or direction to be correctly copied, may to begin with be more of a task than an enjoyment. (See the picture opposite.)

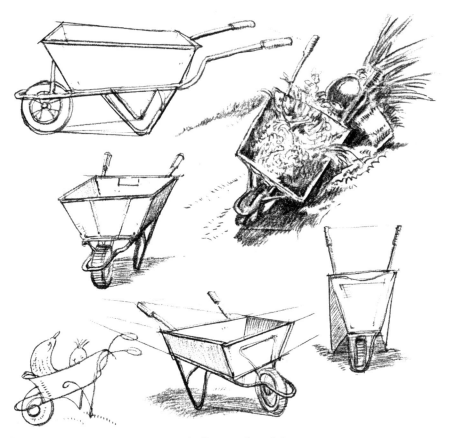

Putting the wheelbarrow through its paces

It is at this point I think that we should know what we mean by copying. It is by *representing* an object *correctly*? Or is it enough for our drawing to *resemble* the object? Has it fulfilled the conditions by which we recognise the subject of the drawing although we are quite aware that it is far from being an *exact likeness* to the original object? In other words, is its artistic worth as a drawing lessened by its obvious lack of *absolute accuracy*? For me the answer is a decided 'No'. Indeed, the very

15

desire to make it a *perfect copy* down to the last detail may rob it of its original characteristics and qualities which delight our eye, by which I mean the *way* it is seen, the *way* it has been expressed and the way that both approaches have been fused together with artistic purpose and technical skill.

So much then for 'dead accuracy' which in itself can be counted of little account and may be dismissed by the very idea a *slavish copy* conjures up. But it should be added that this redefinition of object drawing must not be taken as a way round, an evasion, an easy excuse for clumsy or slipshod drawing. That disdainful attitude which cannot be bothered to get it right is often displayed by sheer incompetence posing as artistic intention.

If you want to get the best out of object drawing, more than one viewpoint should be chosen. If the object is small or light enough to be handled, it is easy to turn it this way and that. What does it look like back view, or seen from above, on eye level or below? I guarantee you will produce some unexpected shapes, some of which are not so easy to draw, but are well worth attempting, and the net result of these multiple studies is in itself a discovery of real aesthetic value and I would say of absolute necessity if you are to be a successful illustrator or rise above the ranks of the average commercial artist.

Nor will you stop at recording single objects, for if drawing and designing become synonymous with your training, you will want to look about for suitable forms which you can now group together, and see further how when you move them around, like people in a gathering, they will sometimes face you and sometimes have their backs towards you.

You will smile perhaps at some of the unlikely objects I have attempted on your behalf, to illustrate this further exercise, but I know by experience that making such studies opens the mind's eye to all sorts of new ideas for future work and as these drawings multiply you will be building up a comprehensive reference library, some items of which can even be pictures in

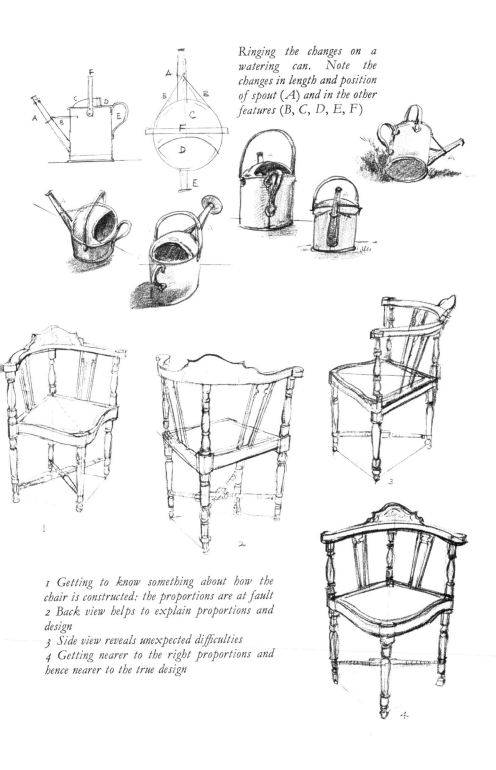

Ringing the changes on a watering can. Note the changes in length and position of spout (A) and in the other features (B, C, D, E, F)

1 Getting to know something about how the chair is constructed: the proportions are at fault
2 Back view helps to explain proportions and design
3 Side view reveals unexpected difficulties
4 Getting nearer to the right proportions and hence nearer to the true design

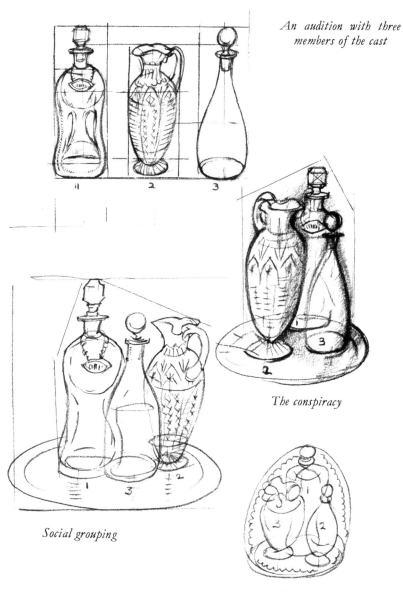

An audition with three members of the cast

The conspiracy

Social grouping

Victoriana

their own right, as the Victorian oil lamp proved to be in producing a subsequent oil painting which I entitled 'Victoriana'.

Having fulfilled this suggested programme of object drawing you will find you cannot afford to lay it aside for good. It should prove to have the very opposite effect as will be realised by the many similar studies that the Old Masters have made of all kinds of unlikely odds and ends at all stages of their careers and which are treasured today as evidence of their continued delight in following this pursuit for its own sake.

It was Albrecht Dürer (15th century), whom Edwin Mullins the art critic has rightly named 'Nature's first draughtsman', 'who was famous for his traveller's sketches which were done to satisfy his curiosity to examine and set down *anything that caught his eye*' (my italics). These individual studies at close hand, drawings of birds' features, flowers, grasses, human hands and feet, should act as an example of a world-wide graphic artist who lavished the greatest skill on the smallest detail, and in whose footsteps we should want to follow.

Have you (as I'm sure you must have) a loft, an attic, a box room or lumber room, a tool or garden shed? As well as in your living rooms, it is in such places of security or retirement that you will find bric-à-brac in all sorts of shapes and sizes and possible stages of disintegration, all offering their services to the cause of art and waiting to act as models for your future picture making.

It is said that it was the background of Neo-Impressionism which led Seurat and his followers to lay so much emphasis on drawing and structure and Ogden Rood to declare that 'The want of *good, decided, approximately accurate* drawing is one of the most common causes that ruins the *colour* of *painting*' (my italics).

Absolute accuracy, you will notice, is not required as long as the drawing is good and decided.

Drawing Down the Ages

TO trace the origin of drawing as a means of making visual communication, we have to go back to the evidence provided by the drawings or stained outlines, those representative symbols or ideographs, remarkably naturalistic, which decorate the irregular surfaces of the walls of the cave man's dwellings.

Here we see depicted with a straightforward objectivity, enormous vitality and confident technical 'know how', aspects of the chief means of primitive man's survival for existence—the hunt, the wild animals they pursued and killed 'for the pot', in other words, the common round, the usual task. And what is more surprising is that these 'drawings' are executed with a skill presumably acquired by long practice. With this in mind it seems very doubtful after all that we are witnessing examples of the first 'self-taught artist'. Further investigation would doubtless reveal some even remoter responsibility for their ability to draw.

For us, however, it is more to the point that drawing, making pictorial signs, however naïve, which can be readily understood by civilized peoples throughout the world, must be accepted as the foundation on which all further art forms have been built, and for this reason alone drawing must command our lasting respect.

We should always be ready and willing to turn for inspiration and technical help to the drawings which have been produced down the ages by the great masters of the medium, even though it has to come in many cases second hand, through the written word and reproduction. George Sheringham in his scholarly notes on *Drawing in Pen and Pencil* warns us that 'A drawing is a thing to be looked at and not written about'. He

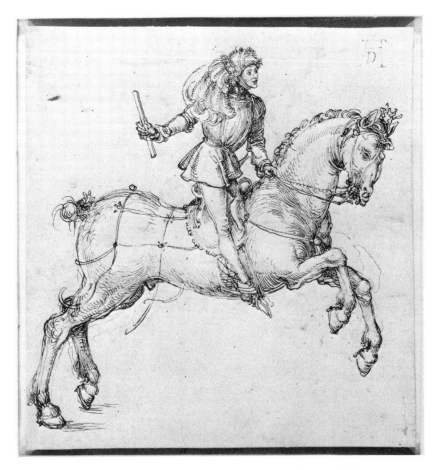

'A Courier' by Dürer. Pen and ink drawing in the British Museum

proceeds to enlarge on this: 'Pages written about it will not make a good drawing bad or a bad one good, nor will they unfortunately really equip and instruct anyone to know the one from the other for the reason that one drawing is justly ranked as a masterpiece while another is thrown away.'

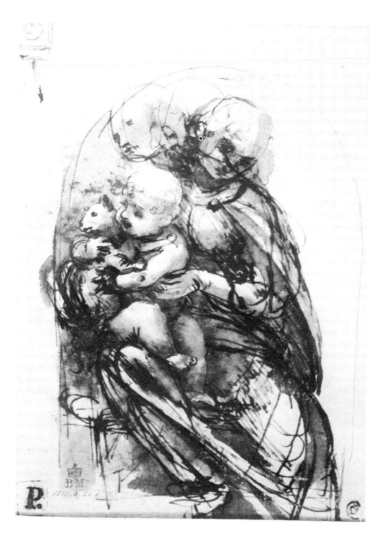

*'Madonna and Child' by Leonardo da Vinci. Pen and ink drawing in the
British Museum*

But anything written, I maintain—especially in these days—that will stimulate and revitalise our interest in *drawing* is worth reading, even Sheringham's own amusing advertising guide to this end: 'Come where it's always light. Now showing all day in the Print Room of the British Museum. The finest collection of drawings *in the world*! Michel Angelo and Leonardo da Vinci supported by an all star company of draughtsmen. Central heating. Perfect ventilation.' Does not that incite one to pay a visit? For the truth is that so few of us who profess and call ourselves art lovers afford themselves this privilege of studying *original* drawings of great artists at first hand.

And it is in their company that we will begin to find out our preference for one drawing against another. In style, perhaps, or subject matter, a Rembrandt religious drawing may be preferred to a similar subject as portrayed by William Blake. Here we will find the romantic appeal in opposition to the classical approach. Here we can compare the secular to the sacred, the landscape to the portrait and interior. And what a choice of mediums greets us by which the artist made his drawing! This might well tempt us to try out for ourselves some different combination of chalk and wash or pen and wash to the pencil which we have been accustomed to and satisfied with.

Here then—picked out as if from a lucky dip—are some master draughtsmen of the past with the titles of their drawings and what they were drawn with. Here, for example, is Giotto (1266–1336) making his lovely drawing of 'Christ walking on the waters' with pen and ink.

At the same period we find that Gardi is using 'tinted paper' to make his pen drawing of 'The Presentation of the Virgin', and, still in the 14th century, the Sienese school were making brush drawings on vellum as well as pen and ink and often 'heightened with white'.

In the 15th century there was a return to pure pen and ink, and silver point on parchment is now mentioned. In this medium any pointed instrument of silver (or gold) was used

on a specially prepared paper washed over with zinc white, producing 'a lightish grey outline' which Uccello (15th century) used with great effect in his drawing of 'An Equestrian Figure'. He further enhanced the effect in this case 'by drawing on a terra vert (green) ground heightened with white chalk against a purple coloured background'. This would seem to be rather overdoing the mixture, but it is interesting to note how many old master draughtsmen drew on a tinted paper. (So why shouldn't we?)

In fact a certain element of experiment was always apparent. We read that Pollamolo (14th century) in his drawing of 'Adam' used pen and ink and a brown wash over the original outline in black chalk, and the Florentine school of drawing favoured pen and wash, black chalk on toned paper, generally heightened with white chalk. They all appeared much concerned with the most effective way of presenting their drawings.

Leonardo used several techniques, pen and ink, brush and brown ink on bluish paper, silver point on 'pinkish paper retouched with pen' and red chalk, generally by itself. In his famous cartoon for 'The Virgin and Child with St. Anne and Infant St. John the Baptist', measuring 4 feet 6¾ inches × 3 feet 3¾ inches, in the National Gallery, London, he used rather surprisingly charcoal on brown paper and heightened with white chalk. This and 'The Studies of Four Demons' are the only examples I have been able to trace of Leonardo's pure use of charcoal.

Pen, mostly with brown ink, red and black chalk and very occasionally silver point, were Raphael's favourite mediums. Michel Angelo generally drew with red or black chalk. Tintoretto was another rare user of charcoal on bluish paper. Tiepolo generally stuck to pen and ink and wash; it so well suited his romantic approach.

To turn from Italy to Holland, we meet one of the greatest of all draughtsmen, Rembrandt. The majority of his magnificent drawings were made in pen and brush. Sometimes he

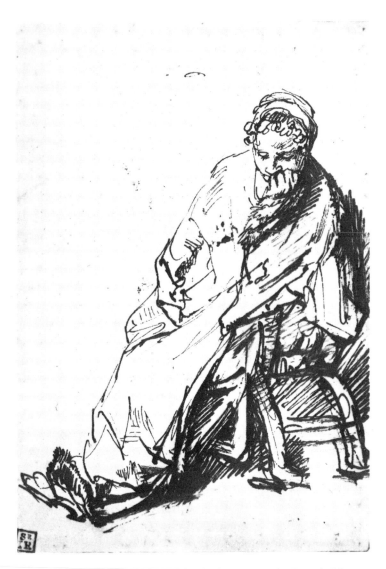

'Saskia' by Rembrandt. Pen and ink drawing in the British Museum

Pen an ink drawing by Rembrandt, in the British Museum

combined red and black chalk on tinted paper and on one occasion (the only one I know of) he used a unique mixture of mediums. You will find this in the Print Room of the British Museum. In his large figure composition 'The Lamentation' Rembrandt brought together 'pen and brush with brown ink—red and black chalk, and oil paint, executed on many pieces of paper of all sizes, and pasted next to and over each other on one large sheet'.

We read also of drawings in which he combined 'brown and grey ink, grey ink on brownish paper, brown ink and white body

colour on grey paper with parts rubbed out with a finger—and often we find 'corrections with white'. When one learns that he made 440 different studies of bible stories alone, some measure of his artistic stature as a draughtsman can be estimated.

In the remarkable Rembrandt exhibition in Amsterdam in 1969 it was his drawings that I found so thrilling, so inspiring, especially where he desired light and shade to give added drama to the scene. For it was in these drawings done in the latter years of his life that one sees the structural effect of his groupings of figures and the dramatic emphasis of the human situation were vitalised by a combination of the living line and the accompanying washes of tone which added a pictorial benediction to each picture and, note, a *picture* in its own right.

I wish I had sufficient room to extol individually the merits of other such masters of drawing as Dürer, Holbein, Ingres, Goya, Watteau, Claude, Daumier, who all handled pen and chalk with a skill that has rarely been excelled, but I cannot close this chapter without special mention of Turner's genius as a topographical draughtsman who brought pencil, *lead* pencil on white paper, to a pitch of pure perfection. Only to look at his sketch book records of Europe and the time he spent at Petworth House is to realise what can be achieved with an inch or two of plumbago in the hand of a painter who left behind him so many drawings and sketches which 'achieved grandeur in small compass', and many of which rank, I believe, with some of his oil paintings.

How all these great artists loved drawing, and how in their several ways they have inspired the art of drawing right down to the present day can be seen in the work of many worthy successors amongst the illustrators, cartoonists and caricaturists, amongst whom can be included such British masters of the line as Charles Keene, Tenniel, Phil May, Muirhead Bone, Max Beerbohm, Augustus John and many others.

Indeed, one has only to compare the labyrinth of whirling lines out of which Topolski ultimately sorts out the features of

his sitters, with the fastidious precision by which Emett picks his ingenious way through a tangle of superb nonsense to create his own particular pictorial world, or to look from the brilliantly audacious originality (thought to be outrageous by his contemporaries) of Aubrey Beardsley's chosen medium with his extraordinary control of the pure pen line, to the warm, honest and robust portrayal of the cockney character so aptly and humorously described by George Belcher's economic chalk line, that the many-sided facets of drawing become abundantly clear in both manner and matter, as each artist makes known his particular offering of style, approach and personal technique.

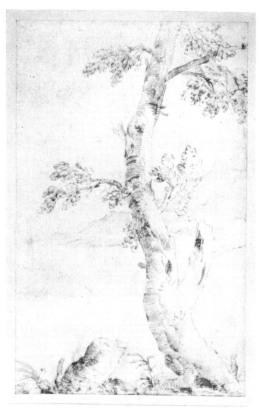

Pen and ink drawing in the British Museum. Marco Ricci (previously ascribed to Titian)

Our Choice of Media

IT has become a truism to say that you can draw with anything —a bit of burnt wood on a white-washed wall to an inch of lipstick on the back of a broken plate. But it might be of more value to the reader if in addition to the varieties of mediums used by the old masters I give a further, more normal choice of materials at our disposal.

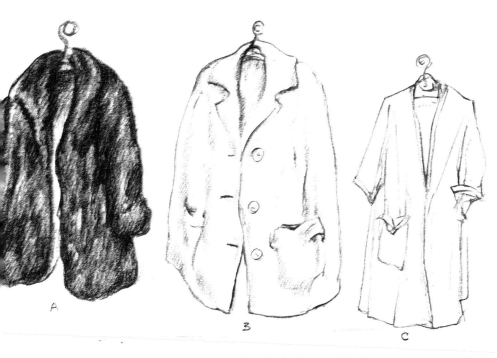

A. Black crayon B. Black chalk C. Carbon pencil (2B)
Choice of medium in depicting A. fur; B. wool; C. cotton material

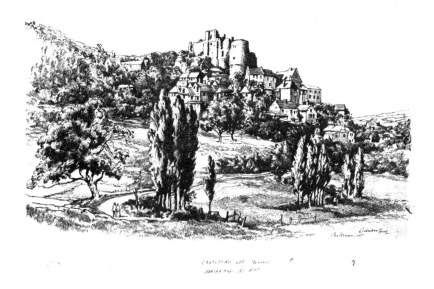

Castlenau, Lot, France. Two versions of the same subject, in pen and ink (above) and chalk (below). Note the slight shift in emphasis in the composition

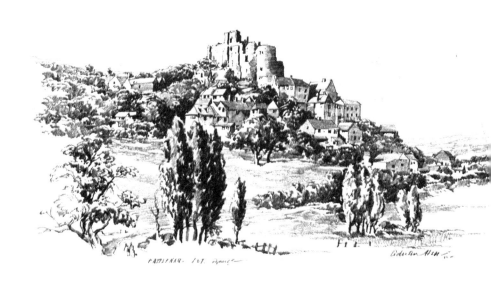

For outdoor sketching lead pencil will always remain popular. It is certainly very handy to carry and is manufactured in a very large range of grades from HH (very hard) to 6B (very black and soft). Over the years I have found that it is liable to fade and in inexperienced hands an overworked drawing can produce a shiny surface.

For many years I retained a preference for carbon pencil which can produce a crisp line for detail and a deep velvet black for shadow forms. It is also excellent for reproduction. (I hear that it is no longer being manufactured.)

Conté (a hard black chalk) I prefer in the four-sided stick form, especially the lithographic variety, whereby one can use the side as well as the point to give richness to shadow forms. As well as in black, it can be obtained in red.

Black crayon, a soft rather gritty chalk, can be very effective when used for making a bold or dramatic sketch, but being thick to handle, it is of little use for a detailed study.

Sketch of a farmhouse in Lot, France, drawn in pen and ink, washed over with a yellow ochre tint

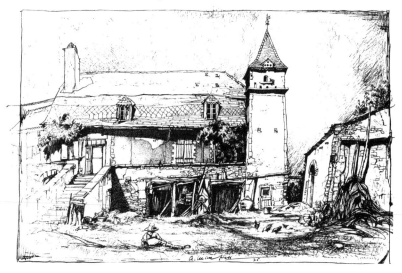

Charcoal I have never used for outdoor sketching, but I have seen effects in nature such as sunsets, morning mists and dramatic cloud formations produced with charming results when the seductive range of tones can be shaded together with the finger or a piece of clean cloth or tissue handkerchief. For any other sort of sketching it would appear to evade any definite statement. It should certainly be 'fixed' as soon as finished.

For pen drawing, there are new types continually appearing on the market. I have used both the ball point and the felt tip and though they are satisfactory for certain kinds of sketching, nothing appears to be so flexible and sensitive as the reed or old-fashioned goose quill pen, when it can be found!

Unexpected precison and delicacy can be produced by a well pointed brush as in the hand of Sidney Sime, the famous illustrator of Lord Dunsany's imaginative stories, who thus combined washes of lamp black ink with a wealth of detailed drawing, with one tool!

Château de Montford, Lot, France. A pen and ink drawing washed over with an umber tint, lifted in parts to heighten light and shade

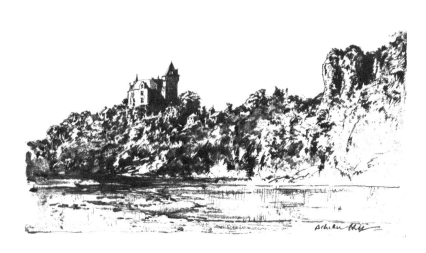

But for all-round satisfaction there are few mediums to touch chalk for figure or landscape drawing—in precision, force, spirit or delicacy.

As for paper, most sketch books contain a good quality cartridge paper. For finer work a 'Hot Pressed' or smooth quality surface known as 'Bank' is found in other types of sketch book or pad. For pure pen and Indian ink drawing, Bristol Bond is still the best obtainable, but it will not take washes of tint.

Cox's paper, which was greatly favoured in the last century, has a definite buff tint, like sugar paper, but with a better quality surface texture, and can be very flattering to a chalk or pen and wash drawing as the effect can be heightened with touches of Chinese white.

Lastly there is Fashion Board, which can take pen, chalk and wash equally well but is best suited for indoor and figure work.

Old Norwood, London
 A wash drawing with Indian ink on Cox's paper (buff tone)

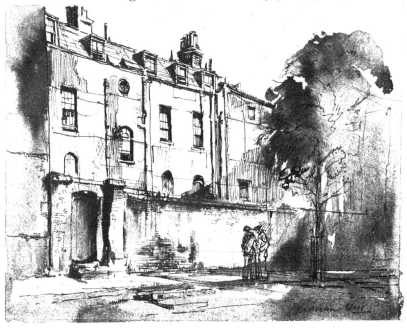

Figure Drawing

IN the gradual but significant departure from the realistic or academic representation of the human form, the principles of basic anatomy are to some readers in danger of being neglected and their importance disregarded, if not, in some cases, completely ignored.

Figure subjects, especially those depicting the nude, which in the past played so important a part in the painter's subject matter and which occupied an honoured place both in our galleries and in the esteem of the picture-loving public, have been for many years now relegated to a position of doubtful aesthetic value.

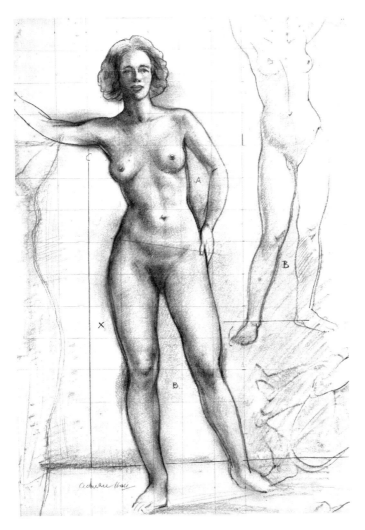

Study of a standing figure. X denotes leg which is carrying the weight of the body. Notice the shapes made between the limbs and body, A, B and C

The ideals of both the male and the female forms cherished and portrayed by the Old Masters have been superseded by the portrayal of other organic forms which, while having a life of their own, bear little resemblance to, let us say, the Adam and Eve which past generations were brought up to believe 'God created in his own image'. Moreover, human physical beauty as something to be revered and copied with loving accuracy has become something of an anachronism and when exhibited in a frame is generally viewed with artistic suspicion (though it is used extensively as a sexual form of advertising).

Of what use, then, is a knowledge of anatomy, implying as it must, a special course of study in the workings of the human body, for the modern student? To understand more clearly this decisive shift of emphasis, it is necessary to recall that figure drawing or life drawing as it was called in my day was placed very high in the list of priorities of the student's training, requiring him to master the principles of proportion, to learn to appreciate solid form and to represent the human form with accuracy, especially in depicting the fore-shortened limbs of the model when taking different poses and to understand what took place in the body when doing so. To help the student to acquire the necessary knowledge and technical ability to put this knowledge into effect, a thorough understanding of anatomy was considered essential for figure drawing, and a skeleton and life-sized diagrams of the muscular system which influenced the surface form was an essential feature of the training

Ten studies of the author's left hand. This is an exercise which will tell you a lot of surprising things about what it can do and what it looks like in various positions. 1, 2, 3 and 4 were drawn as seen in a mirror

The fulfilment of all this specialised study was the worthwhile evidence manifest in the countless life studies and anatomical drawings of the old masters, reproductions of which were always available.

In other words, if anatomy was deemed necessary for such great draughtsmen as Leonardo da Vinci, Michel Angelo and others, how much more was it necessary for us of lesser clay!

I believe, however, that in many art schools today such a highly technical and analytical approach to the subject is no longer considered necessary, and when a drawing is made from the model there are no 'strings attached' as to when and

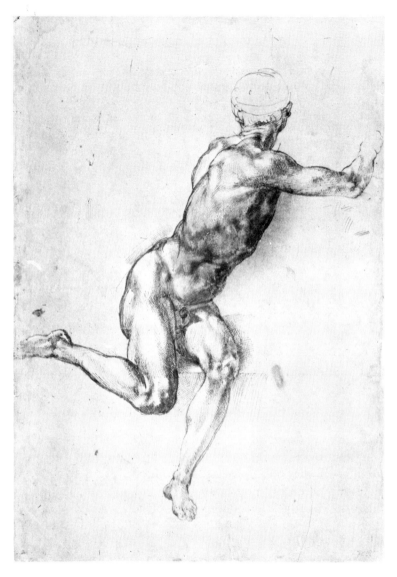

Pen and ink drawing by Michelangelo Buonarroti in the British Museum

38

how the student makes his drawing. The model is, as it were, on hand, for the purpose of reference only—as for the skeleton, it is a relic of the past.

After all, it could be argued that figure paintings, in which male and female posed in heroic attitudes and in idyllic surroundings portraying some legendary or romantic story, are no longer in vogue. The question now becomes 'How much

Studies of posed models for an industrial painting

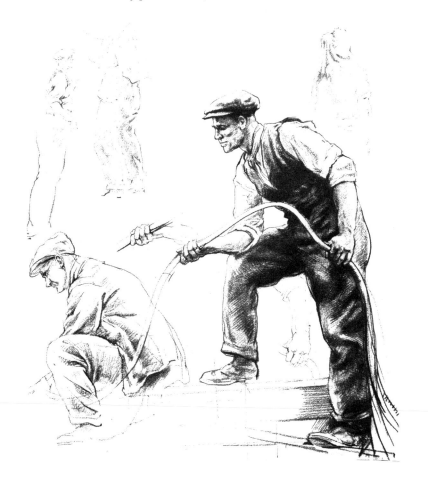

is it necessary to know about drawing the figure?' For it has often been argued that the actual value of such specialised knowledge may well have been overrated. In actual proficiency of acquirement it has often proved a veritable stumbling-block to the sensitive draughtsman, while to some artists it has been absolutely harmful to their work.

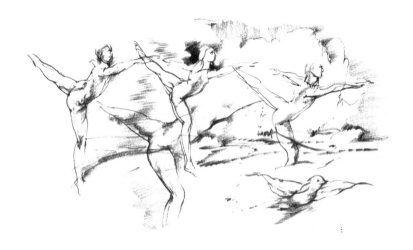

Figures of the dance in action, lead by a bird

On enquiry, however, it can be shown that it was the very rigidity of the instruction (which was paraded rather than taught) which caused anatomy to have been so misemployed. Text book rules became a substitute for knowledge. The medical slant on the body's construction when bones and muscles, torn from their pictorial framework, were held up for isolated inspection and study, had little or no connection with the living breathing human being which the student was required to represent. In fact it often dehumanised or devitalised the very aim for which it was intended.

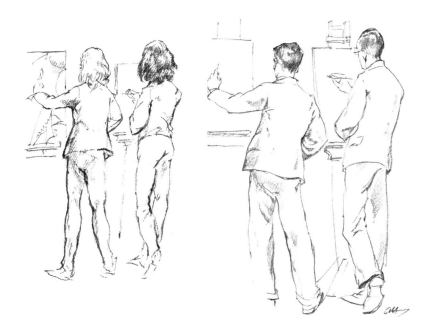

Male students at a life drawing class in 1930 (right)
and how they would appear today (left)

Like perspective, then, which I shall be discussing pre-sently, to be acceptable to the reader, anatomy should be pre-sented as an aid and not a hindrance to his artistic aim, and in no form of stern directive but as a key to turn a stubborn lock and reveal the working parts, without which any figure, nude or draped, young or old, can remain wooden and lifeless.

And it just happens that having been brought up the 'hard way', I still like to believe that some working knowledge of how the body behaves—what goes on beneath the clothes (and is so often quite visible to the passing eye)—is still of real value in giving verisimilitude to the portrayal of any figure, whether it plays a major or minor rôle in your composition.

It is for this reason that I have included the examples of life drawings; those when I was an industrious student, later when I was a painstaking teacher, and finally drawings of more recent date in which figures occur, either in a humorous or in a fantasy world of my own making, in the hope that a logical connection between past discipline and rewarding freedom is apparent and the result acceptable.

For readers who may wish to pursue the subject of life drawing further, I have dealt with it more fully in a previous book in this series, *Drawing and Painting Faces and Figures*.

Where no organised life classes are available, one has to rely on a friend who will volunteer or is persuaded to sit for you in your home. Now this is a very different exercise from drawing in a class where a professional model is employed and the student can settle down to regular sittings without concern for obtaining a likeness or for the comfort of the sitter! With a friend, the desire to obtain a pleasing likeness, the natural concern for his or her comfort ('Are you getting tired?') against the tactful reminder to keep still ('Would you just keep the head up a little?') can prove unexpected distractions when you need to concentrate all your attention on the technical problems involved.

Among such problems are to see that your sitter's face is well lit, either from the right or left, to experiment with dark or light backgrounds so that the modelling of the features is clearly defined, accentuated or even dramatised, and to discover whether the character of your sitter is best expressed in a full face, three-quarter view, or profile.

But let me say that to begin with the wisest course is to make a series of careful studies of your own likeness in a looking glass, searching out proportion: width between the eyes; length of nose (so often too long); checking the distance from the curve of the nostril to the outside edge of the mouth and the correct placing of the ears in relation to the corner of the eye and the angle of the chin.

42

Sketch portrait of A. E. Cox

From drawing the head, get your friend to take some natural sitting position, relaxed as in reading a book, or knitting—the head in most cases will be lowered and thus foreshortened—or looking at the television set, when the body will perhaps be more upright, and the head and features more alert.

In any case, the characteristic position must be established first by 'scaffolding' or guiding lines lightly drawn in, and if need be corrected, before attempting any concentration on features, limbs or drapery.

In short, grasp the essentials first and elaborate afterwards.

43

The direction of the small crane was a fortuitous aid in the composition
Compare 'Barges at Port Sunlight', page 55

<div style="text-align:center">

CHAPTER SEVEN

Composition

</div>

WHAT do we mean when we say that a drawing is well designed, or is lacking design? For the word composition is one of those time-honoured terms in the vocabulary of art that has had lip service paid to it rather than it being fully understood and carried out. It is always recognised with due respect as being all important, but it is often, or so it seems, a hit or miss with the student, whether his drawing or painting is well or badly *put together*—for composition, etymologically speaking, is nothing more or less than putting together material, whether with deliberation or by instinct is immaterial.

The object of the artist as composer may be formulated in several ways. As an artist, like a poet or a musician, his desire

must be to express himself in his chosen medium. As a musician he uses sounds, as a poet he uses words, and as an artist he uses form and colour, but they all need to be put together, arranged or composed. (In another context, composed is to be in control!)

Are there, then, any fool-proof rules to be observed in the composition of a picture, and how rigid can they become? Are they more flexible as skill grows or as conditions demand? After all, it is only theorists who lay down hard and fast rules for composition, in order to codify personal experiences, and so forge an aesthetic link between the artist and his audience. If the artist violates these rules through ignorance, or overlooks them through haste, and finds the link between himself and his audience is in some degree weakened, then he must be bound by the rules.

Bristol, England, after an air-raid in 1945. A down-to-earth working drawing to be enlarged for a painting, recording the bomb damage. A is the eye of the picture, B and C leading the eye to the focal point at A, and D and E essential for recording purposes, but difficult to keep 'up stage' and not attract attention

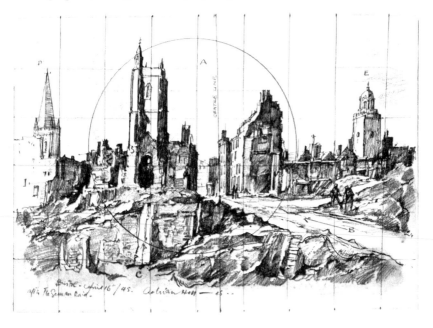

If, however, the artist can maintain this indispensable link at full strength and on repeated occasions while infringing what is accepted by the theorist as a rule, he has every right to do so. This principle of freedom has been carried into effect by every great painter. Indeed I would hazard a guess that there is hardly a rule in the text book on this subject that cannot be found to have been repeatedly disobeyed with complete success by masters of their craft at one time or another.

Rules, then, should be accepted mainly as safety-first devices for the inexperienced and they have a high value as such. Their danger lies in the fact that they can, and unfortunately often do, establish a formula, thereby enabling the unwary to turn out with little thought, acceptable compositions which carry a guarantee that they can never affront the beholder by incompetence and thus court criticism.

Now whatever subject is chosen for our drawing one of the first questions to be settled is whether this particular subject is a vertical or a horizontal one, whether it is better suited to reveal

St. Anne's Hill, Midhurst, Sussex. These two pictures show the same subject seen first as a horizontal and then as a vertical. Between doing the two drawings the lighting had changed and I made other alterations to the second drawing

the pictorial qualities of height, width or distance. It has been proved by most painters, I believe, that the exact square is the most difficult shape to fill.

Judging by the number of horizontal landscape compositions which predominate in any art exhibition, it would appear that this is now the generally accepted *shape* in which to design our paintings, preferring as we do to express nature 'spread out' rather than 'hung up'. But to say that most views of nature are more logically rendered better lengthways than vertically is to be at once reminded of such famous pictures as Constable's 'The Cornfield' and Turner's 'Crossing the Brook'

and thus guard ourselves against generalisation! On the other hand, a growing prejudice against the long horizontal picture (sometimes known as 'the chimney piece painting') is more understandable and I believe fair comment, as it limits the possibilities of anything more adventuresome in the way of composition than the panoramic vista (which generally induces the viewer to *look across* it instead of *into it*) or that of presenting an acceptable two dimensional pattern.

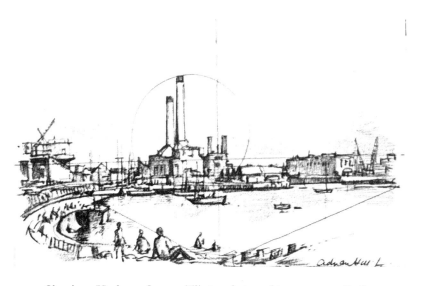

Shoreham Harbour, Sussex. The two factory chimneys are well off centre and the figures help to direct the eye up and round the curve of the basin to the central focus of the picture

Having said this, one is reduced to repeating one or two self evident and long accepted warnings which may have been forgotten. One is that the balance of sky to earth should not be equal. A line drawn *across* your paper or board should ensure that you place your horizon above (however slightly) or below it, thus establishing what is known as a high or low horizontal composition.

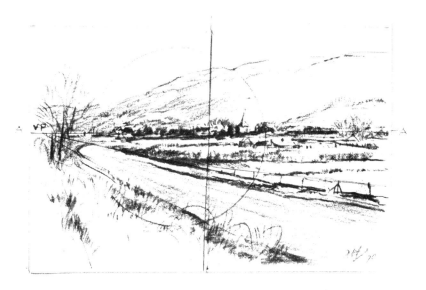

Road improvements in Sussex, England. Notice the directive lines, horizon lines, and eye of the pictures, the balance of the sky and the points of accent. A, Horizon line; VP, vanishing point

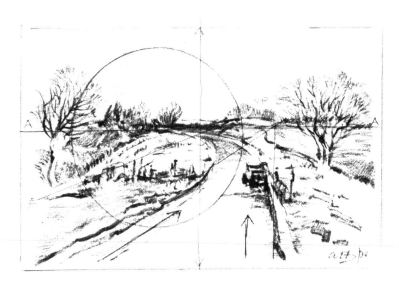

Neither (I hope you will remember) does a balance in composition mean an equal distribution of similar forms on either side to support the main interest, but the avoidance of detailed form or forms concentrated on one side of the picture only. Balance can be obtained in various ways: a cottage or haystack can balance an upright tree—a bank of clouds can offset the weight of an opposing clump of trees. In short, a right sense of balance will exclude anything approaching a rigid symmetrical pattern and can be seen to work by studying the paintings of accredited painters.

Converging lines by winding roads, rivers or fences are shown to be very effective in discreetly guiding the eye to the focal point of interest, just as long cast shadows, which may direct the eye out of the picture, will be reconsidered.

All these should be welcomed as artistic devices rather than expedients; in fact as auxiliaries in the production of an acceptable design, so that they will be sensed rather than seen too obviously. Imagination and invention must never be lost sight of, in both grouping and arrangement. A lack of boldness, when the grasp on essentials is surrendered can often be traced to the deadly flattery of a well tried composition.

A practical device which can help the student with making a first selection of a possible subject is what is called a view finder, which can easily be made. All it is is a mount cut out of some board or thick paper of which the opening need not be more than, say, 6 inches (15 cm) wide by 4 inches (10 cm deep). This can be held up in front of the eye to survey the view, which is now revealed within the boundaries of a frame. The nearer the mount is held to the eye the more of the scene is included, which can equally be restricted by extending the arm away from the eye. Another advantage is that the subject may be viewed as an upright as well as a horizontal composition, depending on how you hold the card.

In either case this method concentrates the gaze on some particular feature in the landscape while excluding the sur-

rounding countryside. Thus by slowly moving your view finder, horizontally or vertically and at varying distances from your eye, some hidden subject will often be pin pointed. This disclosed view will nearly always need some minor composi- tional readjustment as the personality of the artist is imposed on nature, in order to obtain a good design.

The temptation, when a finished drawing is seen to be poorly composed, to reshape it by cutting off a strip of unwanted foreground, shaving off an inch or two of sky or trimming one or other side in the hope of achieving a better design, should be resisted. The new composition always shows signs of being drastically reconditioned, and for this reason alone 'cutting one's cloth' should never become a habit!

Birdham, Sussex. The boat, A, was brought in from its real position at X. The group of trees, B, was moved nearer the centre of the picture, C. The drawing was made in carbon pencil with touches of white on a tinted background

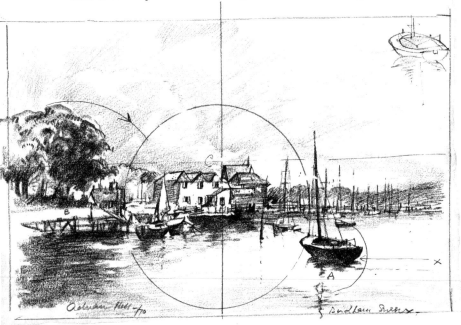

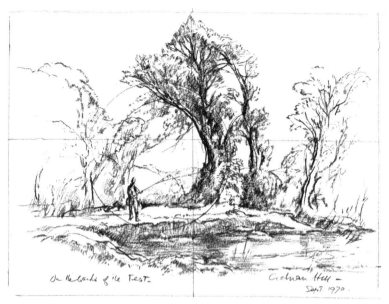

On the banks of the River Test. In this case, it was a matter of selection and elimination to preserve the nature of the composition which was prompted by the two bending trees and the standing fisherman

I find it impossible to conclude this question of composition without a word of warning to those who continually employ the use of a camera, and to explain its usefulness and its misuse. The advantage of having some fleeting glance of nature permanently recorded, which can be studied at leisure and copied with exactness on some future occasion, is all too obvious. It can, however, be a mixed blessing. One of its dangers is that it makes us lazy when we become quite content to let the camera make our composition for us while we abide by what its mechanical eye has registered. And if I am right in having said that nature rarely, if ever, provides us with a fool-proof composition, it follows that the camera merely confirms this fact.

Certain compositions are happily dictated by the particular viewpoint of a subject, such as the 'bird's eye' view as opposed to the horizontal when seen at ground level. But in the main,

nature very rarely presents the artist with a ready made design. Moreover, as she is invariably over-lavish with her properties it is left to us to sort out what we decide is necessary and what is redundant. And even then certain further eliminations may have to be considered before an acceptable composition is arrived at.

While we are able as producers to eliminate, rearrange or add a scene, where a better design is desired, the photograph, revealing all, prompts us to do the same.

The high view point offered me this attractive composition, only obtainable by looking down on the subject and seeing all the unusual features from above.

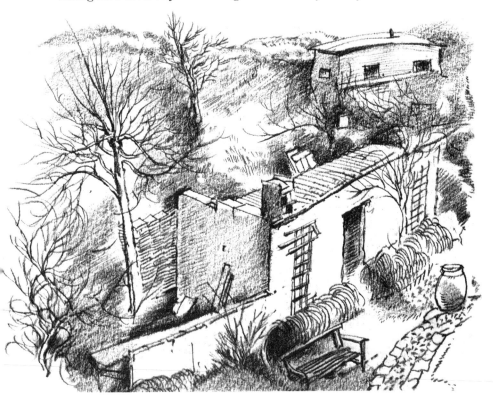

Barges at Port Sunlight—an example of what to leave out!
The mobile crane at the right could have pointed into the picture

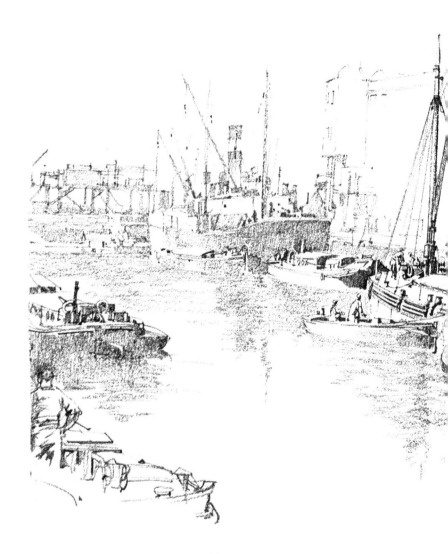

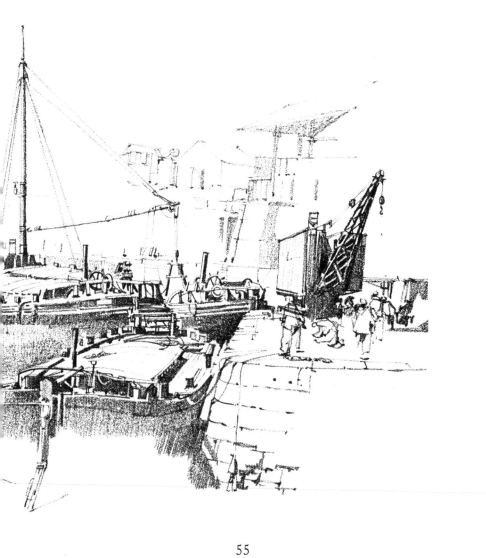

Of course we need not literally *copy* the photograph; indeed, we should be able to effect certain changes or modifications as we would in front of nature, but all too often, in my experience, when we are away from nature we forget what made us *want* to draw the particular subject, and we are all too ready to reproduce what the camera has impersonally recorded. It can rarely inspire our eye as the original did, and will never do so if we are tempted to draw or paint from a photograph that we have not taken but simply found in some magazine.

But if the camera can be found to aid us little in composition, it can certainly provide us with a source of authentic reference, with novel view-points and a host of detailed information which in many cases may be difficult to record with any accuracy on the spot or in the time at our disposal.

But I have an idea that for all of us and our artistic souls it is better to find that we have left the camera behind! Let us be our own producer and leave the photographer to vex himself with the drudgery of cataloguing the obvious.

The Square, Northbeach, Oxfordshire. An experiment with alternative composi-tions. How much can the eye take in—ABCD or EFGH or BFAH? This was drawn with a 3B carbon pencil

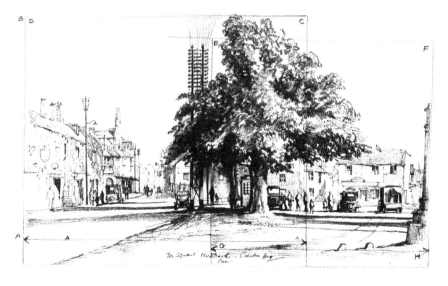

Perspective

IN the memorable painting of 'The Rout of San Romano' by
Uccello in the National Gallery we see the first benefits
derived from the development of the art and theory of pers-
pective. It was experimental as most three-dimensional painting
was in those early days, but how it helped to convey distance!
By the time we reach Canaletto the problems of space and dis-
tance and their solution were completely mastered, although I
have always suspected the too easy assistance offered by the
*camera obscura** in those pioneering days.

I know that despite this, perspective still remains an ominous
word to many students. It conjures up a complicated set of
mathematical rules which only a mathematical mind can under-
stand and enjoy working out. For example, 'to find the vanish-
ing point of lines perpendicular to the surface of a given
inclined plane' is, I admit, enough to put anybody off. But to
embark on a book about drawing in the fullest sense of the
word and leave out perspective altogether is like presenting
Hamlet and ignoring the ghost!

As far then as the artist is concerned, perspective should be
regarded as an indispensable *aid* to drawing correctly what we
all see. To spare the time to learn and understand one or two
simple fundamental rules, which when applied can be *seen*
always to answer the problems of projection and recession or
depth in pictures, is certainly no waste of time. As long as we

* The *camera obscura* is a piece of photographic apparatus with dark
and light chambers, projecting on paper, for tracing, images of distant
objects.

consider such elements as necessary for representing nature *naturalistically*, perspective is always ready and willing to come to our aid.

May I begin by assuming that the axiom that all parallel lines if extended to the horizon will eventually appear to meet is generally, if vaguely, accepted? What is not generally understood is that all lines parallel to each other (except those parallel to the horizon, and 'uprights',) whether on the *horizontal plane* or the *vertical plane*, must meet on this one horizontal line.

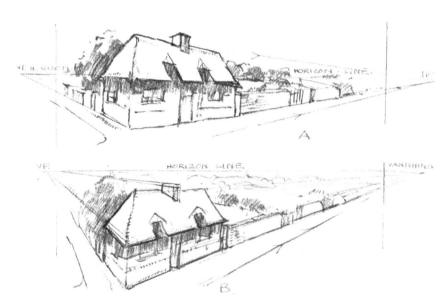

The same house seen from two angles: top, from ground level, with low horizon; bottom, looking down, with a high horizon

For just as the width of a road narrows according to the distance it goes, so the parallel lines of the *roof* line and the *base* line of a house also grow less and the *height* of the house diminishes in proportion to the distance it appears from the beholder. This fact, for it can be seen by the eye, also applies to

a wall, a line of telegraph poles or pylons, a fence or hedge—any form, in fact, which has a top and bottom equal in height will appear to decrease as it goes away, and if extended to the horizon the lines will, or rather must, meet!

Once this optical illusion has been tested out and found to work, perspective is robbed of its sinister application of T squares and rulers, and securely harnessed to its proper job of helping the student to improve on his composition which should always aim at getting the beholder to *look into* his picture.

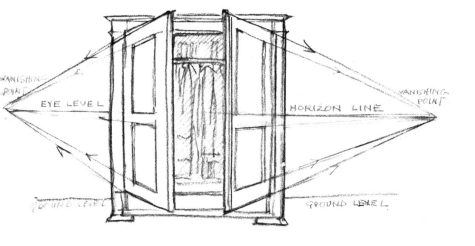

What you actually see; there is no other way of showing that the cupboard doors are open

One very self-evident truth, however, which is often surprisingly overlooked, must not be omitted. There is only *one* horizon line and that line always remains level with your eyes. Whether you sit or stand or climb to the roof of a house, the horizon is always at eye level. Try it for yourself. And however many vanishing points are required they too must meet

on the *one* horizon line, whether the meeting or vanishing point occurs *inside* or *outside* the picture plane, i.e. the fixed dimensions of your drawing.

Three vanishing points of a sea wall, in perspective

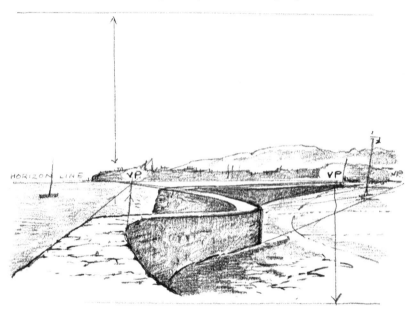

In the picture on the opposite page I hope the reader will see (more clearly than any text can hope to explain) how perspective works and how useful it can be in landscape painting. Indeed you cannot go far wrong unless you forget the principles I have just referred to, for only perspective can render distance correctly and convey the right degree of recession between one object and another, and only a proper understanding of the rules can offer the artist a variety of viewpoints (according to where our horizon line appears) from which *one subject* can be successfully drawn and render each one a welcome variation on the same theme.

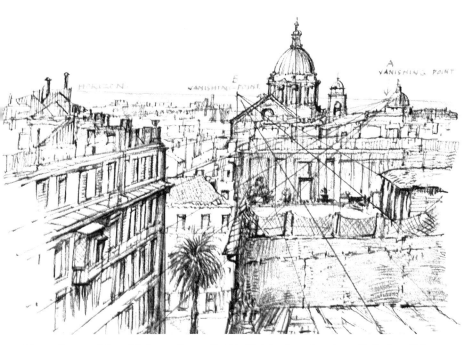

From the top of Spanish Steps, Rome. In this high horizon drawing, all the parallel lines go up to the horizon, those on the left to the vanishing point A, *those on the right to the vanishing point* B

I have said elsewhere and on many occasions that a lot of liberty appears to be taken with perspective by a number of contemporary artists, but it is still true to say that you can only break the rules or have a right to when you know what you are breaking and the reason for so doing. In short, perspective should never narrow your vision or cramp your imagination, for there are occasions when a properly equipped artist can dispense with principles and press on with his purpose. For it must be remembered that no real draughtsman likes his drawing to be praised *only* because it is properly drawn in perspective— although this may only just save it from being a bad one.

And this I hope has now put perspective into its proper perspective!

61

CHAPTER NINE

The Use of the Sketch

CAN a sketch be defined merely as something drawn in haste or left incomplete? At the beginning of this century there was a widespread opinion that a sketch was nothing more than an unfinished picture, a brief account without any detail but carrying a general hazy idea. This slighting judgment was directed at much landscape sketching done direct from nature and at last it became a challenge to the artist to prove that such a sketch could be a distinct work of art, separated from and different to the deliberate effort of the artist, conveying in the fullest manner the swift vivid impression of the place.

Drawn from a car park in Bristol whilst waiting for the shopping

62

Ball point, one-minute sketches

Normally, I suppose, a sketch is content to reveal a quick analysis of the form and materials which can be said to comprise the scene, providing sufficient reference for the artist to paint from it. P. F. Millard, the distinguished art teacher, puts it this way: 'To learn how to make use of a drawing for further expression needs careful consideration and experiment. For a working drawing should have in it an idea to be unfolded and enlarged or sufficient data to enable the artist to carry out and complete an idea already born. Inconsistency in *outlook* between the working drawing and the final expression means that the artist does not know what he intends to accomplish.'

In other words, the working drawing is first and last a working drawing to be worked *at*, as well as from. And although it is rightly said that while the beholder may merely look for the impression of the moment in a sketch, it can, when properly executed, disclose the experience of a lifetime, combining the spontaneity of the sketch with the enduring satisfaction of a complete picture.

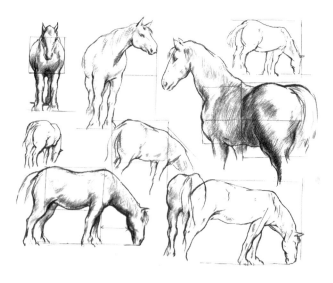

Out to grass

How true this is may be seen in many a small pencil sketch by the hand of a master draughtsman like Turner. Not only does he 'achieve grandeur in a small compass' but each drawing appears to have sufficient authentic detail for a large painting, despite the fact that many of these sketches, I believe, were never intended to be anything more than evidence of Turner's own delight in making the sketch *for its own sake*. Many a sketch, on the other hand, is obviously made only as a means of collecting material to fill in gaps in a painting which hitherto has been found lacking in authentic detail. Such a working drawing may look over-worked in the artist's desire to record as much as possible from which a final selection can be made.

Often a careful selection from the properties available is sufficient to give point to a particular subject which the sketcher has in mind, and which will decide him on the best medium to employ when it comes to be painted. Many sketches, however, though sincere enough, lack pictorial 'bricks' or 'meat' re-

64

quired to build robust paintings. Many drawings of my own that I have not looked at since I made them are as nebulous in this respect as details of a dream.

In fact, this sort of sketch which figures in certain art magazines under the title of 'Leaves from the Artist's Sketch Book' (and in which some of my own work was reproduced) suffered badly from a meretricious dexterity of handling. The 'touches', the dainty symbols, were far too 'sketchy' and functioned only in their own minute artificial world, that of the size of the sketch book. To enlarge any portion of them would at once disclose a paucity of tangible detail, and in most cases they lacked any serviceable light and shade, in the real sense of these words.

It would therefore appear that if a sketch is not intended as a working drawing it must contain special qualities as will merit its inclusion in any exhibition of individual records or impressions where the factor of the hand is linked to a personal quality of vision, whether it be of a romantic or classic turn of mind. I will be enlarging on this special problem in a chapter on 'The Pencil on Holiday' for it is here that we can so easily slip into making a merely 'pretty sketch'.

Drawn from a car park in Truro, Cornwall

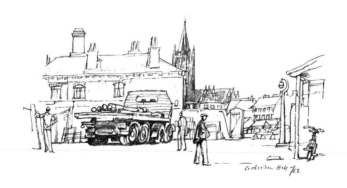

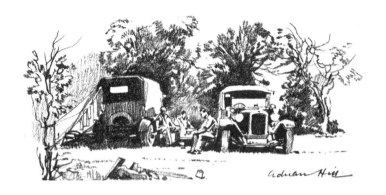

CHAPTER TEN

Sketching Out of Doors

ARMED with some preliminary warnings, one or two sketching pads or books of good cartridge paper, plenty of pencils or chalk, a light, folding sketching stool, all of which can easily fit into a satchel which in its turn can be carried over the shoulder (leaving the hands free for opening and shutting gates and mounting fences, etc.) we are ready to explore the countryside.

Now whereas in object drawing we were concentrating on representing one form which we had purposely detached from its surroundings and isolated for our closer inspection, we are now confronted by a great number of different objects of varying sizes and shapes at varying distances from us and each other, none of which can be physically picked up one by one for our special study! We see them in company and in their own habitat and in scale with their surroundings, and have now to make our selection accordingly, on the spot.

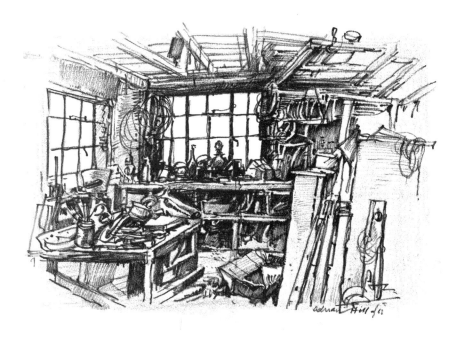

We can approach our selected subject, for example, an old country church and isolate it from its distant surroundings, but if we get too near to it, the front porch will be found to take up so much room that the body and tower of the church are crowded out. This is a very common fault. Quite recently a student friend of mine, wishing to make a study of a particular tree, found she had drawn the trunk and was nearly at the top of her paper before realising that there would be no room to get anything like a *portrait* of the tree on to her paper.

Now if you cannot see the *whole* of your chosen subject, whether it be a single tree or a whole church, *without raising your eyes*, you must move back until you can! If you don't, you

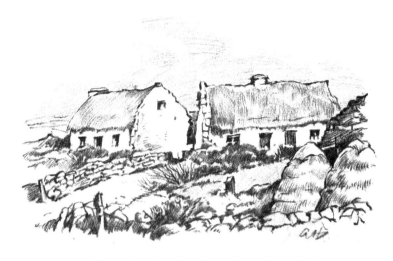

A five-minute sketch made on the road in Ireland

will be in real trouble; it will be another example of 'no room for more'. As a precaution, leave a sufficient margin—$1\frac{1}{2}$ inches or $1\frac{3}{4}$ inches (4 cm) all round your paper so that there will be space enough for the foundation of your church with its silhouette of tower against the sky, or the roots and crown of your tree to be free to proclaim its species. The 'all over' *shape* of the forms is all important. We must now be able to estimate the room necessary for the inclusion of their essential features, determine their size and proportions, and convey these characteristics within the limits of our paper.

A forgotten consideration should be mentioned here: the allowance of time for making our sketch. 'Oh, I must just make a sketch of that' should be accompanied by the question 'Have I *time* to make another sketch?' On looking through our bag when we return from a morning's or day's sketching, it is sometimes apparent that our last hasty sketch suffered from just this lack of time, too much of which may have been expended on a previous drawing.

Weather, of course, can and does condition the extent of our work, and I know to my cost the hazard of attempting to finish a pencil drawing in the rain; which in its turn reminds me that if you are drawing with chalk, carbon, Conté or crayon, it is advisable to fix each drawing as soon as it is finished, and it is certainly a 'must' if you are working in charcoal.

For sketching, a hard chalk, which can be used freely for shadows and half tones, is I find far better for details which demand a crisp accent or a sensitive contour. Such soft materials as charcoal or crayon, which I have already mentioned, while enriching tone and enhancing atmosphere, are employed only at the cost of sharp definition. But if the artist happens to be a scrupulous draughtsman 'with an instinct for design', as Sir Charles Holmes once put it, 'his natural talent will easily resist and overcome this danger.'!

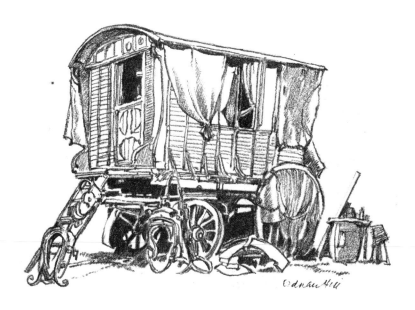

Shoreham, Kent

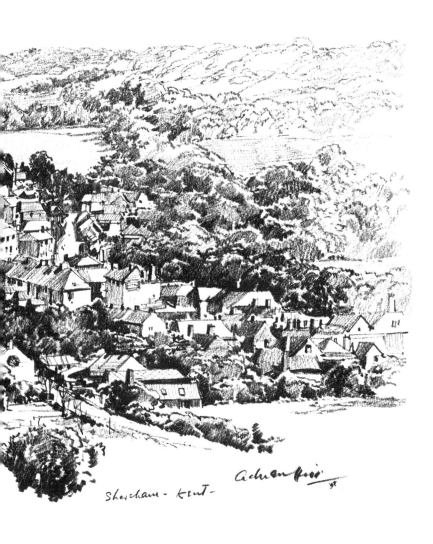

Shoreham - Kent -

Drawn on the spot 1928!

71

The Pencil on Holiday

TO record the pleasures of a holiday at home or abroad by the means of a well stocked sketch book is infinitely more profitable and far less expensive than purchasing the all-too-familiar picture post card and photographic brochure, both of which are rarely up to date and hardly ever correspond to your own personal preferences for subject or viewpoint. It is just a matter of taking your courage in one hand and your sketch book in the other and then starting out in search of suitable subjects.

While I admit there are many justifiable objections to drawing in the streets of our capital towns and cities (to start to make a drawing in London is almost to invite arrest for an obstruction!) but take your pencil abroad, say to Paris, Amsterdam, Florence

View from Boboli, Florence

Street scene with bust of Benvenuto Cellini, Florence, Italy

or Venice and I guarantee that you will feel in no way con-
spicuous wherever you elect to make a drawing. Most foreign
countries love the artist, whatever language he speaks or (as in
my case) however falteringly he struggles with their own
tongues. Nobody appears unduly curious, and if they show
interest, then they do so sympathetically.

Above all else there is hardly a street, square or boulevard
that, while it offers you subjects galore, does not at the same
time provide you with a table and chair and a cup or glass of
something into the bargain. And what is more, if it should
rain there appears always to be an awning over your head.

73

It is, of course, one of the chief and most civilised amenities of many picturesque towns in Europe that its streets should abound in cafés which extend their invitation by spreading their tables and chairs on to the pavements, inciting the visitor to take a seat and to contemplate in comfort the passing pageant of humanity with its infinite variety of types; and once seated, I defy anyone not to feel the itch to open his sketch book and sharpen his pencil.

'It all started with a lamp post'

In your immediate surroundings you will be certain to find something to draw. It might well start with the glass partition through which is framed a glimpse of the cafe next door with its flapping awning, by which you get the *feel* of your surroundings and the *taste* of the pictorial menu at your disposal.

First, a warning—one of many—for the beginner who is about to practise in public. Do not embark on a complete picture. Content yourself by making notes or collecting reference material. A general impression of a particular street can be made up by a series of its detailed parts which very often and by some mysterious process form a composition. Let me give you an example. In my little haphazard notes of the corner of a street in Montparnasse in Paris (opposite) as I savoured the scene, I became aware of the line of static forms, solid immovable lamp standards, rooted like a number of disciplined giant sentries lining the street. Here then was a typical and characteristic form of lamp post which I could safely start to make a study of, and I drew the nearest as a detailed study towards the centre of my paper. I did not hurry over this drawing; if I drew nothing else I had noted something perhaps peculiar in design which was only to be found in that part of Paris.

But I did not stop there. I decided to give the lamp post its comparative height by drawing in some pedestrians and the other two lamps, in perspective. Next came the side of the line of shops on the right, as well as a suggestion of the buildings on the opposite side of the road. And I didn't stop there because I got interested in the behaviour of the occasional *gendarmerie* who frequented the neighbourhood; and so it grew. And it all started with a lamp post, which forcibly reminds me that Mr. Pecksniff in *Martin Chuzzlewit* was very close to the truth when he said 'To draw a lamp post has a tendency to refine the mind and give it a classical turn'. And when you are 'on the job' you will find that drawing is total involvement. Time and even a persistent audience make little impact.

It is 'anybody's guess' which foreign country or island provides the promised land for the sketcher. I put Holland, the *Midi* in France and Tuscany in Italy high on any list of favourite sketching grounds. To me, every small town beckons equally in these vastly different and remote regions, but here again, a danger has to be faced: the typical view, the beauty spot, the medieval castle, the famous square, the ancient cathedral, ruined abbey, all the picturesque trappings, canals, bridges, inland waterways, ruins, land and water gates, appear to be lined up and all crying out their wares. Do not be tempted to sit down and draw the first that catches the eye. Do not feel you must join the sketching party all sitting or standing round the market cross with its background of ancient oaks and picturesque village shops; your sketch will probably be as conventional and hackneyed as the rest. Make enquiries from the natives and the odds are you'll be told of some locality that the tripper misses and where you will discover something that is worth making a special journey for, for the sake of your sketch book.

Flower market, Bruges

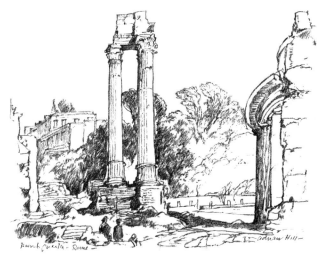

The Jewish quarter, Rome

It is so frustrating when you are showing your 'bag' to some friend who perhaps was the means of deciding your visit to this particular spot, when he or she says 'Oh, you should have gone on to . . . or taken the little road to . . . ', or 'What a pity you didn't make a sketch of . . . , any native would have told you . . . it's just round the corner'. How many really well worth-while sketching subjects are 'just round the corner'!

As nearly every sketcher provides himself with a camera these labour-saving days, all I would suggest is that you do not use it if there is time to make a good drawing, for what you see is so much more sensitive, human, exciting and dramatic than the automatic, mechanical, deadly monotonous, baleful gaze that the eye of the camera lights on nature, turning it at best into a 'still life' and at worst 'still born'!

Just a word about time and place, the 'when and where': once you have learnt *how* to draw and what medium best suits your purpose, you will find wherever you may happen to be that there is always something to draw, something that is worth

drawing and, curiously enough, something that you have *never seen before*, that is, seen through the eyes of an artist. I know how many times I have bitterly regretted leaving my small sketch pad behind and thus missed a golden opportunity of adding to my reference library—my pictorial property store-cupboard.

Having cultivated a gift of artistic observation and developed a similar memory, you will find that once you have put down the essential lines, the rough lay-out may even be sufficient to recall the scene as you first saw it, but to rely on this so that when your little drawing comes out of the 'deep freeze' it will thaw out sufficiently for you to mould it into a good composition, will need a very practised hand. For sketching like this necessitates that deliberate pause to consider the why, the what and the how of the subject, so that you will be able to give urgency to the matter of its portrayal and thus charge it with meaning.

To light upon an unusual collection of 'still life' and preserve its fortuitous arrangement with the authority of your eye and hand and produce the final product long after the original bric-à-brac has been dismantled or destroyed, is a bonus gift which I can recall grasping with gratitude and savouring with smug satisfaction! (You see, I had my sketch book with me.)

My small sketch book came to my aid again when travelling in France many years ago to make a swift—very swift—sketch of one of those giant French steam engines standing at an adjoining platform, where it was working itself up to a perfect frenzy of impatience, while I prayed I could finish my drawing before this huge, black, reeking monster, with belching smoke and steam escaping from all over its encumbered body and from under its countless wheels, was allowed to depart. Oh yes, sketching can be very exciting, especially when the scene, in this instance and as I remember it, was lit by a sunset of glowing crimson glory, enhanced by the ghastly, greenish,

furtive station lights; all this combined with the prolonged ear-splitting hiss of steam to make it appear as a historic episode of tremendous significance. And this evocation of the past is re-lived for me in the sincere, if inadequate, little sketch which I venture to include here.

It was not that I was unused to this challenge of the passing moment. Had I not many years previous, as an official war artist, executed many drawings of the changing face of the country-side, the subject matter of which was literally being destroyed before my very eyes? However, I had become very much *out of practice* in drawing 'with a stop watch'. I was certainly 'kept in condition' again when for eight years I sketched to a strict time table in *Sketch Club* for B.B.C. television. The moral of all this is: 'keep up the sketching habit'.

I would add as a postscript that with hindsight every artist has his own idea of the ideal sketching ground, but his favourite locality, whether at home or abroad, can be a potential

danger. We have all suffered, I imagine, from this devotion to a certain type of country or county. I found all I wanted, or what suited me at the time, in Suffolk, and I have spent many—perhaps too many—happy working holidays round and about Walberswick. The low horizon subject, the low tide, the small craft heeling over in the mud, fascinated me, until I found it was making a slave of me.

The Sussex coast, especially where the compulsive sailor has his boat, has made in recent years an even greater appeal (because it was far handier to my home town) and I became a potential addict to the estuary and harbour crafts, although not as a sailor, I hastily add.

Now I hope I am fully emancipated, and am almost equally artistically 'at home' in whatever place we may happen to choose for a holiday, There is always something new in the configuration of the terrain, in the architecture of the towns and villages, in the changing face of the countryside—bridges, pylons, skyscraper flats and multiple stores and the sinister octopus growth of the great motor roads, flyovers, underpasses—which I find all challenge me as an artist. For they can all be utilised in our picture making and all provide data for our sketch book.

Cap Ferratt, south of France

Drawing from Memory

IT is not, I hope, irrelevant to the subject of sketching from
memory to remind myself that it was as long ago as 1929
that I was elected chairman of the Langham Sketching Club.
To become a member of this unique association—one of the
oldest in the world, I believe—the candidate was required to
make a sketch from memory of a subject, the title of which
was only announced before the hour struck for him to begin
work. Two hours were allowed for this trial of skill and he
could execute the sketch in any medium he chose.

The Langham Sketching Club. The subject was 'Men at Work'

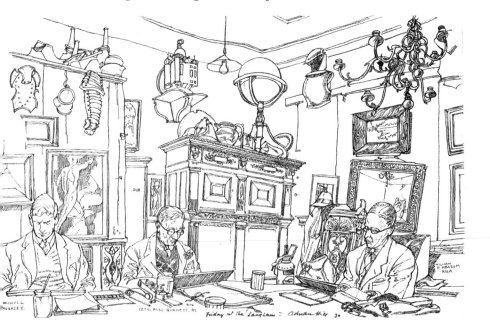

The quarry, an imaginative drawing in lithographic chalk

My subject—I shall always remember it—was 'The Procession'. Although our membership was drawn from the ranks of the professional artist and consisted of several well-known commercial artists, the conditions imposed on the candidate 'up for election' caused similar nervous reactions to those experienced before an important examination. In my case a sudden inferiority complex immobilised my brain and drawing hand and it was only after many minutes of anxious mental research that I managed to produce an idea which materialised into a procession of pilgrims winding their way round the base of some ruined castle or historic building, the gaunt pillars of which were silhouetted against an angry sky. I found I had just sufficient time to tint my drawing with two washes

of transparent colour and these may have helped me to be duly elected!

Once elected, we used to meet each Friday and after tea the title of the subject for the evening was announced by the chairman of the year and for the next two hours silence reigned, except for the occasional muttered oath when things went wrong. We worked in our own particular medium and it must be confessed that some of the older members were very clever in bending the subject round to meet their own particular requirements, whether they favoured landscape, seascape, interiors or humorous settings.

I rarely missed a Friday session and I can certainly look back on those working evenings with nostalgic pleasure, not the least of which is the memory of our remarks when we showed our work and could approve or criticise each others' efforts with refreshing candour. I learnt a lot in seeing the various ways we all approached the composition of the subject and the techniques we employed, and since those days I have often wondered why so little drawing and sketching appears to be done in company, for when two or three are gathered together a spirit of friendly competition often produces surprising results. In my experience it is the *subject* that triggers off the sort of picture that one has in the mind's eye. In confirmation of this I remember on one occasion—never to be repeated—I gave 'Optional' as the subject of one of my TV Sketch Club programmes, and without the incentive of some particular subject my young viewers seemed at a loss to think up something for themselves. This rather suggests that complete freedom, even in the art world, can emasculate the creative urge.

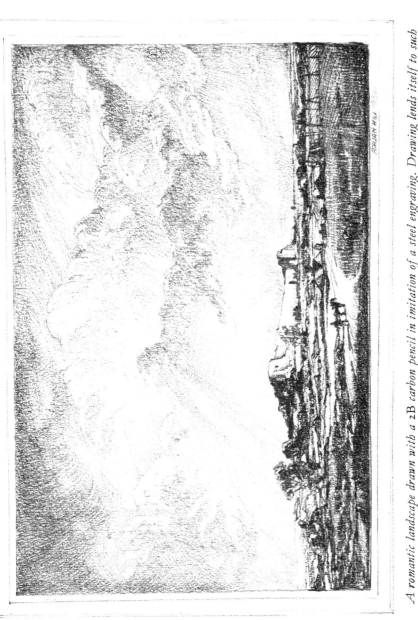

A romantic landscape drawn with a 2B carbon pencil in imitation of a steel engraving. Drawing lends itself to such light-hearted deception.

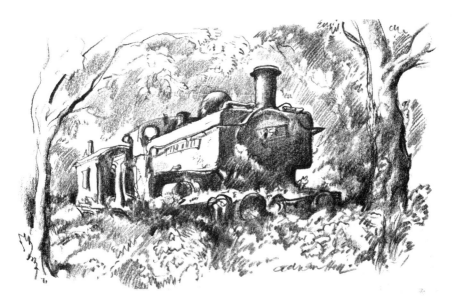

An 0–6–0 Pannier tank engine which lost its way!

CHAPTER THIRTEEN

Imaginative Drawings

DRAWING from memory is surely the first step to
drawing imaginative pictures, for all works of imagina-
tion must stem from a retentive memory and the 'all seeing
eye'.

No artist has ever invented any completely new pictorial
forms, whether of human beings or of nature. No artist can turn
his back on one or the other and proclaim that he has invented
something original only to be discovered that his 'new' creation
is based on some primeval foundation. A snow-flake under a
microscope puts all modern design in its place.

What he can do, however, and has done with great success is to rearrange the usual order of things—his pictorial properties—in a personal way and in an unfamiliar setting, in short drawing 'out of his head'. His pictorial forms can be exaggerated, distorted, and even disfigured. Unusual episodes now appear in fantastic situations. The rule of artistic order becomes a surrealistic metamorphosis and the 'lord of misrule' governs all. The unpredictable meets the unbelievable and astonishes the viewer's eyes, and the ordinary now becomes the extraordinary as in the dream world where all appears logically real.

I found drawing a great help when recovering from illness, and here, after my third operation, I pictured my 'other self' saying 'What, again, Adrian?'

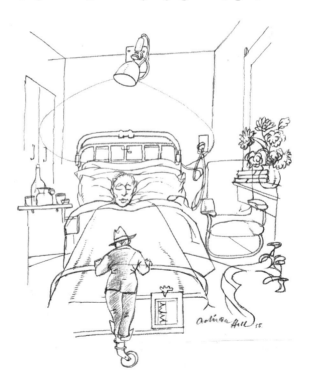

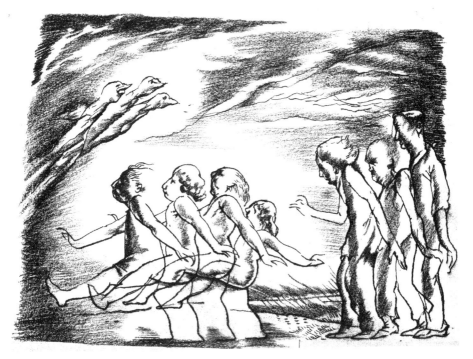

Left, left, left . . .

Of course, pure fantasy, when it comes from the written word is often impossible to illustrate. 'The Quangle-Wangle sat on the top of the crumpety tree.' 'His face you could not see on account of his beaver hat' is, I think, a fair example. Even Lear, who was a considerable artist as well as a famous writer of nonsense poems, did not attempt to portray that or indeed much of his imaginative writing.

What I had in mind is better perhaps explained by the following examples of my own 'flights of fancy' which, as you can see, have no intention to shock or to embarrass, but merely to entertain or tempt the viewer to speculate on 'what it's all about', when the artist is free to follow, rather than dictate, the plan of operation.

87

I suppose one could call it a controlled form of 'doodling' and as such no rules need apply, no warnings or advice are called for, except perhaps that when the children of your fancy have finished their explorations, you must 'collect' them for the homeward journey, by which I mean that as producer you must now take control so that the 'adventure' is made legible by means of a fitting composition or design, in which it is framed.

In addition to letting the imagination wander as I have suggested above, there are interesting possibilities by selecting a certain shape from a subject and developing it to form a rhythmic pattern; adjusting spatial concepts for an imaginative effect; translating a three-dimensional object in terms of colour or texture. Although these ideas depend initially on the seen object, they are not attempts at realistic portrayal, but constitute an imaginative *interpretation*.

A composition based on the shape of an oyster shell

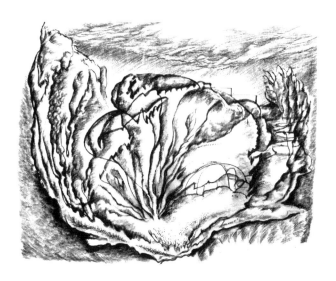

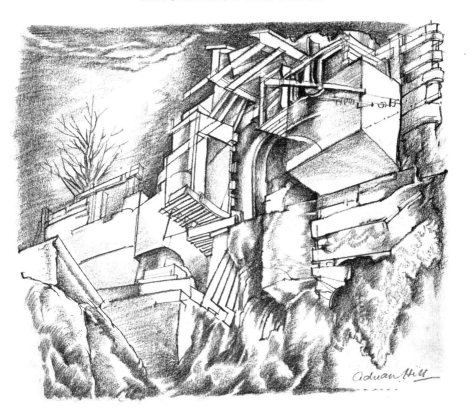

Line upon line . . .

Such care-free excursions into 'the world of make-believe', into that pictorial period of 'once upon a time', I heartily recommend to all who grow at intervals weary with the responsibilities of improving their rational drawing. To them I would say you can relax with a pencil as well as with any other spiritual or medical aid, and when refreshed you will return to take up the burden of your present drawing problems and their future progress with added gusto.

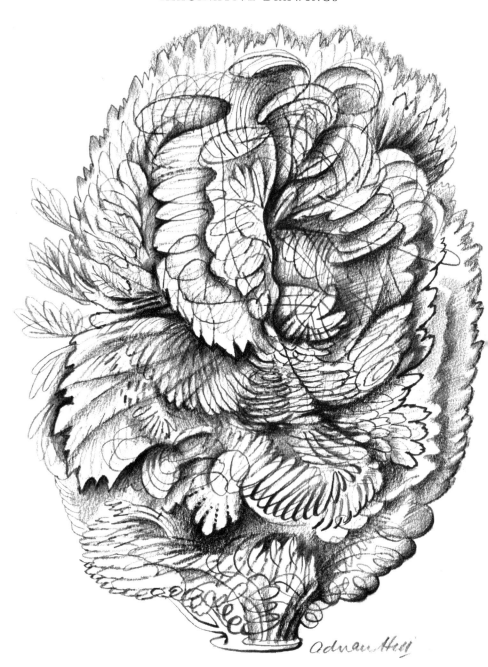

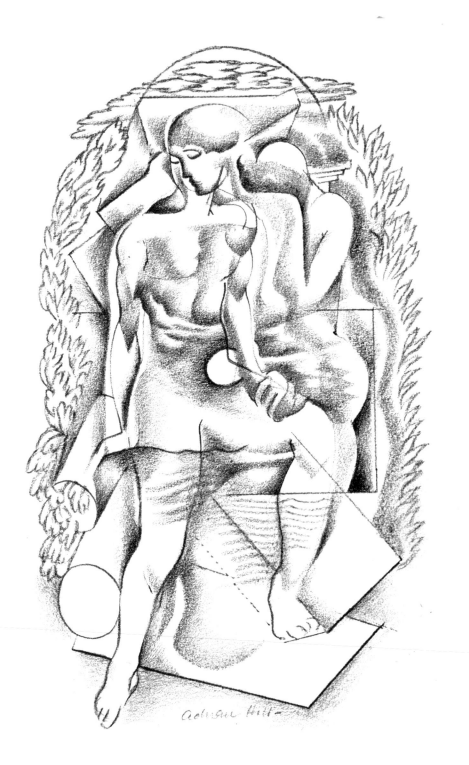

CHAPTER FOURTEEN

Some Conclusions

IN bringing to a close this little work, may I quote from the Italian painter Cennino Cennini (14th century): 'When you engage in art, begin by adorning yourself with these vestments, Love, Reverence, Obedience and Perseverance. And do not fail as you go on *to draw something every day* (my italics) for no matter how little it is, it will be worth while and it will do you a world of good.' Though written so long ago, I believe this is still valid today.

And what an all-round intrument a pencil is! It has the authority of a baton to interpret the order of features which compose a sitter's personality as well as possessing the magic properties of a wizard's wand to conjure up the memories of the past. With a pencil (or pen and chalk) hard facts can be stated with accuracy and conviction and the most elusive fancies suggested with charm and credibility.

With a pencil one can invent, plan and build, or relax into experiment and speculation. A pencil can be used to record or explore, to cause laughter or tears. Sometimes in the hands of the untrained it may obscure when it most wants to reveal. And although a pencil is known to incite as well as inspire, to degrade rather than uplift, its power to illuminate and edify remains all powerful.

To quote from George Sheringham again: 'A lead pencil after all can be only the bitten stump on the office boy's desk or it can be a cunningly wrought stick of plumbago in a cylinder of cedar. Is not the artist capable of an alchemy that can change dross to gold?' Certainly this same medium has proved time and again a trusty weapon to ward off *ennui* and depression, a sure defence against the stress and strain of modern life, and a means of enjoying the best of the visual world around us.

A sepia wash drawing of a veteran Spanish chestnut, drawn with a brush.
See page 67

Adrian Hill